RICHARD GERSTL

RICHARD
GERSTL

Diethard Leopold

HIRMER

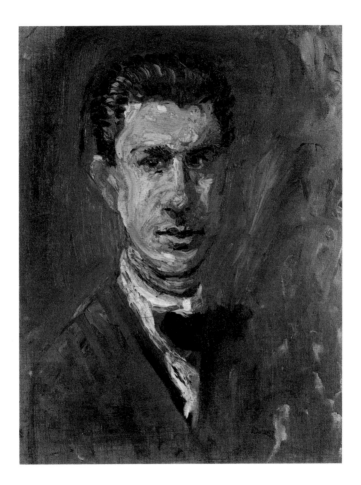

RICHARD GERSTL
Small Self-Portrait, 1907/08, oil on canvas, 47 × 37 cm
Kamm Collection Foundation, Kunsthaus Zug

CONTENTS

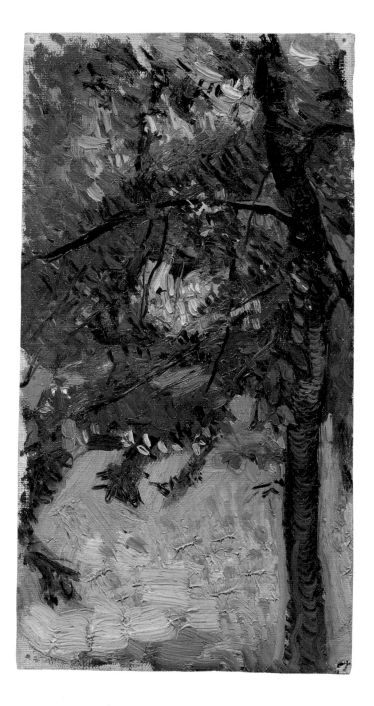

RICHARD GERSTL
AUSTRIA'S
FIRST EXPRESSIONIST

Diethard Leopold

For as long as I can recollect, the first and last self-portraits by Richard Gerstl hung side by side on a wall in our home (figs. 2 and 3). I can remember the very different impression the two paintings had on me as a child as if it were only yesterday.

The first painting, closer to the entrance, showed a half-naked young man whose body emanated a supernatural radiance. He cast a stern glance at all those who walked past him and encouraged them to be just as they really were. He showed that there was no need to hide anything or to be ashamed – unless you were living a false, artificial persona. In that case, the intensity you encountered would set it ablaze. But – and that was the promise made by this picture – if you looked into those eyes long enough, you would become what you actually were.

The second picture showed a completely different man: considerably older and thinner, with shadowed eyes and pinched lips. He presented himself and his miserable existence as if he were a beaten dog – a warning that, in his own case, appeared to have come too late. But I did not know that at the time. The picture radiated something destroyed – and destructive: a kind of voodoo magic. You had to be careful about looking at it for too

1 *Tree with Houses in the Background*, 1907
Oil on canvas, 35 × 19.4 cm, Leopold Museum, Vienna

long. It sent a message that was exactly the opposite of the one transmitted by the picture alongside it.

Today, I think that the child was right in his feelings about the paintings. Gerstl wanted to create something that went beyond being merely beautiful. Apparently he wanted to transcend the limits of the canvas. And it was also possibly this intensity that ultimately broke him.

In any case, it was difficult for me to ignore these paintings.

Richard Gerstl (1883–1908) was the first Expressionist in Vienna in the years around the turn of the century. Although he was active shortly before Oskar Kokoschka (1886–1980) and Egon Schiele (1890–1914), the three formed a trio of radical artists whose work looked forward beyond their own time. In contrast to the other Expressionists, the intellectual-psychological penetration of reality and, above all, of mankind played a significant role. However, they were completely distinct from each other. Aesthetics without reality was foreign to all three artists and this made them the antipodes of the Secessionists around Gustav Klimt (1862–1918), who tried to please their audience. However, Kokoschka and Schiele had a good relationship to the "prince of painting" from the previous generation, while Gerstl resolutely rejected him. When the offer was made to exhibit his works in the Galerie Miethke, which was very important at the time, Gerstl turned it down with the arrogant demand that, first of all, the Klimts there would have to be removed.

THE SINGULAR MAN

Gerstl was considered an eccentric. You never knew what to expect when you met him, given that he not only suffered from extreme fluctuations of mood but also expressed himself correspondingly. That meant that he was absolutely self-assured and convinced of his superior intellectual position, but also – as often happens in such cases – easily irritable and quick-tempered at times and then, at others, closed and taciturn. In spite of that, he must have also been friendly and well-mannered, scholarly and well-read, because he was a welcome addition to the circle around the composer Arnold Schönberg (1874–1951) for a long period. In short, Gerstl was difficult but very interesting.

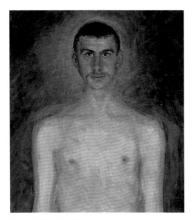 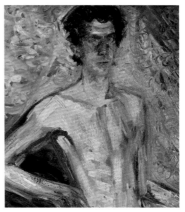

2 *Semi-Nude Self-Portrait*, 1902/03
(detail, see fig. 5)

3 *Nude Self-Portrait with Palette*, 1908
(detail, see fig. 35)

Unfortunately, he was his own worst enemy. He copied the old masters in the Kunsthistorisches Museum in Vienna. Once an elegant elderly gentleman commented on his work and Gerstl rebuked him for meddling when his opinions were unasked for. When the man turned out to be the director of the museum, he summarily denied that he had any understanding of art. Gerstl made disparaging remarks about Heinrich Lefler (1863–1919), the only teacher at the Academy who liked his work and even made it possible for him to have a studio of his own; when Lefler contributed to the jubilee procession commemorating 60 years of rule by Emperor Franz Joseph, Gerstl observed that to do so was dishonourable for a genuine artist.

Obsessively, he felt that he had always to defend everything he stood for against all and sundry – even if he had not been attacked. This all contributed towards the creation of the image of a man who felt – or knew – that he was misunderstood and unappreciated.

PAINTING AS A SEARCH

His painting was a search, an experiment, but without a quest for cheap success. He was obviously concerned through his several styles with the question of how to portray the world as a multitude of sensations and

feelings without a stable ego.[1] With very few exceptions, he oriented himself less towards the Jugendstil à la Carl Moll and Koloman Moser which was fashionable at the time, and more towards the tendencies coming out of France: Vincent van Gogh and the Nabis – especially Pierre Bonnard and Edouard Vuillard – and towards Edvard Munch and Max Liebermann (figs. 8, 9 and 10).

Gerstl only used the technique of Pointillism in a divisionist manner, separating the individual spots of colour, for a short period. In the years after 1905, he rapidly developed an increasingly free form of expressive painting. In his self-portraits and landscapes, as well as paintings of individuals and groups, he drove art almost manically in the direction of a style of colour painting bursting with energy that dissolved the external forms (figs. 26 and 27).

It is a great tragedy that many of these attempts were very probably simply thrown away in the years after his death. At the time, it was impossible to grasp the relevance of his search, much less understand it. For years, Gerstl was considered to have had a failed existence. That his demands were not exaggerated was not acknowledged until long after his early death; his full importance has probably only been fully recognised today.

THE FATAL AFFAIR

The previously mentioned friendship with the composer Schönberg and his wife Mathilde (1877–1923), which was doomed from the beginning, played an important role in Gerstl's biography. For more than two years, the close exchange between the two men, who were kindred spirits in their uncompromisingly pioneering attitude, was a great source of inspiration. In the years between 1906 and 1908, Gerstl was definitely a happier – and, above all, livelier – person than is often perceived in clichés of the tragic artist.

However, the ménage à trois, with its oedipal undertones, resulted in a crisis for the Schönbergs and a catastrophe for Gerstl when the affair between the married woman and younger man became public knowledge. Rejected by Mathilde and ostracised by the Schönberg circle – but still surprisingly for those close to him – he took his life in 1908 at only 25 years of age.[2]

Other artists have answered the question of how his art would have developed for him. Gerstl remains alive in them to this day.

Those works in which he anticipated decisive aspects of twentieth-century art stand out in his small œuvre and we will discuss them in more detail in the pages that follow.

MODERN ICONS

It is probably characteristic of the Austrian variety of Expressionism that both the first and last important paintings created by Richard Gerstl happen to be self-portraits. The two pictures, which are stylistically miles apart, demonstrate his path from overcoming Symbolism to an individual and expressive art form.

Interpreting the two pictures from the point of view of art history and autobiography is an essential component of the project in which the personality of the artist becomes a mirror of reality. This is where visual art catches up with what happened in literature in the Romantic Age one hundred years before, and it is in no way coincidental that this took place in the Vienna of Sigmund Freud (1856–1939).[3]

CONCRETA VERITAS

If one compares the *Semi-Nude Self-Portrait* (fig. 5) with the artistic statement of the *Nuda Veritas* (fig. 4) by Gustav Klimt, which was created only three years previously, the significance of the dawn of the new century between the two becomes immediately understandable. Klimt's painting is still firmly entrenched in the Symbolism of the nineteenth century: the young girl's body symbolises the – beautified – truth: it is an *indication* of this without actually *being* this in its imperfection. Gerstl's revolutionary painting on the other hand shows his own, gaunt body.

The self-portrait of the artist as a nude was a conscious breach of taboo. It is not possible to date this picture exactly; the moustache on the artist's top lip would seem to point towards 1905 but the statements made by some contemporaries and the stylistic distance to the double portrait of the Fey sisters (fig. 4) indicate an earlier date. Be that as it may, if Gustav Klimt

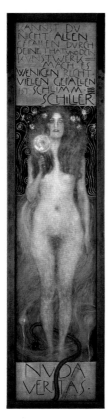

4 Gustav Klimt, *Nuda Veritas*, 1899, oil on canvas, 244 × 56.5 cm
Theatermuseum, KHM-Museumsverband, Vienna

had portrayed himself as a semi-nude as a reaction to the public debate over the scandal of his paintings on the ceiling of Vienna University, it would have been a sensation and a landmark in the history of art. However, in the case of an unknown artist, the picture only triggered feelings of unease among the few who saw it; its revolutionary significance went unrecognised.

At the same time, Gerstl played with the aesthetics of Symbolism: the flesh and loincloth shine immaterially and the artist himself emerges out of a mystical, aural space. The temptation to attempt to interpret a deeper sense, a cultural significance, into the work is great. The loincloth is reminiscent of the esoteric cults that were in fashion at the time; contemporary viewers were reminded of the biblical Lazarus and there is an iconological

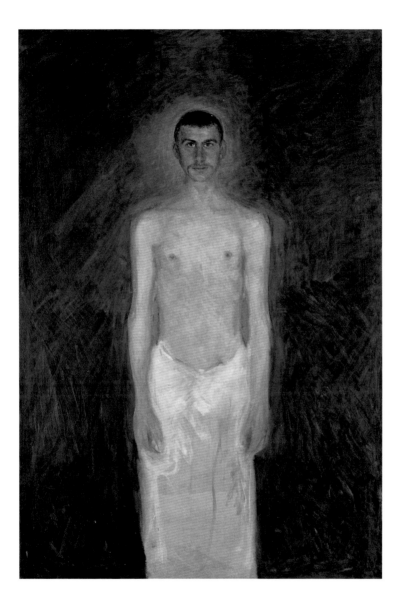

5 *Semi-Nude Self-Portrait*, 1902/03
Oil on canvas, 159 × 109 cm, Leopold Museum, Vienna

connection with the risen Christ.[4] It is precisely this tension of the symbolic on the one hand and the rejection of any kind of deeper meaning through the concrete self-depiction on the other that this work aims at. Its truth is concrete.

THE GAZE AS A TRANSGRESSION OF LIMITS

However, the painting does not limit itself to this one statement. It informs us that the concrete reality can be enlarged; namely, through the consciousness of an artistic individual. In this case, Gerstl does not locate existence in the purely physical. The self-depiction culminates in the gaze of the subject that the viewer cannot escape from even though it intimidates him – or precisely, because it does. This gaze hovers between silent perception and provocative defiance. We do not know what we have become involved in when we confront it. That is the reason that this painting has been interpreted in so many ways: as the expression of a crisis; as the rejection of any further communication; as a challenge to enter into a process of looking at each other in which personal limits are violated or transcended.[5]

The confrontation with this portrait creates a supernatural, even precarious, atmosphere. However, if we confront this gaze for longer than the infamous three seconds that, statistically seen, a museum visitor grants to a single picture, we also sense something encouraging, something brightening. The shimmering body and the gaze forcing its way out beyond the border of the picture resemble a candle. Of course, seeing that the face is coloured more darkly, this candle is also dark and glows from within.

In this way, the painting formulates a paradox that is typical of icons: the confrontation with this man – in an icon, the redeeming Saviour – first of all makes the viewer aware of his nature and this then leads into his own inner being; in a manner of speaking, from the awareness of the other to self-awareness. Gerstl plays with these ambivalences with great mastery.

The interpretation of this painting as an emphatic concept of the self – and as a summons for the viewer to follow suit – is supported by the biographical circumstances. According to his fellow artist Victor Hammer (1882–1967), with whom he shared the studio, and his own brother Alois,

6 Carl Moll
*Hohe Warte: The
House of Therese
Krones*, ca. 1902
Coloured wood-
cut, 42.4 × 42.4 cm
The Leopold
Private Collection

Gerstl painted this picture in the winter of 1902/03 when he was only 19 years of age.[6]

After spending a period in the painting school in Nagybánya in Hungary run by Simon Hollósy (1857–1918) – who, with his international orienta-tion, encouraged his pupils to paint freely – Gerstl returned to Vienna and rented a studio in a lovely house in one of the city's suburbs. It was the self-conscious new beginning of a young man.

Many prominent Secession artists, including Carl Moll and Koloman Moser, lived nearby, as did Gustav Mahler and his wife Alma, as well as her later husband Franz Werfel. Carl Moll made a coloured woodcut of the house in question, the house of Therese Krones at Hohe Warte 37, that also shows the studio (fig. 6). It appears that Gerstl spent most of the years 1903/04 there reading extensively and studying languages. He also attended concerts within the dynamic musical life of Vienna and even toyed with the idea of becoming a music critic.

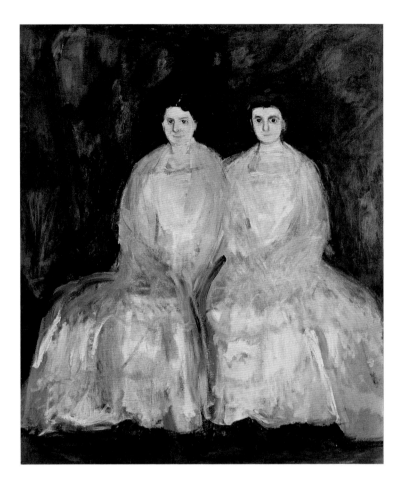

7 *The Fey Sisters (Karoline & Pauline)*, 1905
Oil on canvas, 175 × 150 cm, Belvedere, Vienna

With the painting *The Fey Sisters (Karoline & Pauline)* (fig. 7), which he created in the spring of 1905, Gerstl's art reached another early peak and was a singular achievement in the milieu of the period. In this work, the portraiture only serves as the vehicle for something completely different. The two female figures shine out of the abstract background like ghosts, like light-spirits, that probably have very little to do with the persons who can be identified biographically. The sophistication of the colouration and the vitality of the brushstrokes that make this painting what it is, are hardly detectable in a photographic reproduction. Pink, yellow, blue and ochre tones can be found in the white although it appears to be sculpturally compact; the sofa is indicated by a russet colour leading into lilac. The picture is dominated by the complete freedom of the brushstrokes that creates a moving structure through strips and lines. The upper bodies shine with the greatest purity while the two faces withdraw into more subdued hues: the older sister's eyes are shadowed in olive green while in the case of the younger of the two these are blue.

The dark recess in which the two figures are sitting appears to be just as immaterial. Similar to the figures, the room is invested with an incredibly light sense of movement. This results in the appearance and intellectual content entering into a close interconnection that cannot be disentangled. A fleeting glance could lead us to interpret something like melancholy into the painting – a feeling of the presence of death, the underworld of the shadows. However, if we surrender ourselves to this painting without any bias, it reveals a profound sense of satyr-like humour concentrated in the gaze of the two female persons.

The elder one looks, slightly impishly and somewhat superciliously, to the side – it is impossible not to have the impression that she is completely aware of what is happening in front of the canvas. The younger sister, on the other hand, gawps (there is no other word for it) straight ahead, and without any pretence, at the viewer. Her expression is ambiguous: does it show panic on the part of the subject – sitting for a portrait with a painter like Gerstl was probably not a completely enjoyable experience – or is it the irritation on the part of the viewer who has the feeling that this owlish look has seen right through him?

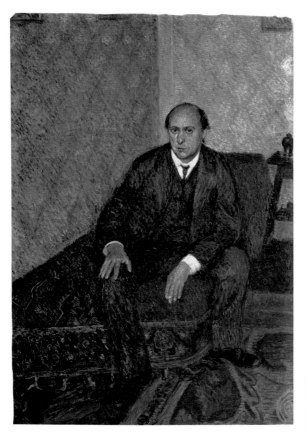

8 *Portrait of*
Arnold Schönberg,
1906, oil on canvas,
182 × 130 cm, Wien
Museum, Vienna

There was one person who appreciated the portrait of the Feys in spite of the newness of the depiction: Heinrich Lefler, a professor at the Academy, recognised that it had such strong qualities that he admitted Gerstl into his special school in the 1905/06 winter semester. At the time, Gerstl was intent on painting portraits of famous persons. Gustav Mahler refused but Arnold Schönberg, who probably enjoyed the attention, asked his acquaintance, Lefler, about the young artist. Lefler recommended him and Gerstl gained admission to the circle of musicians who had set out to free themselves from the tight corset of tonic – or, tonal as it is commonly called – music.

Gerstl did all he could to prove himself worthy of the commission and possibly to get others. He therefore took one step back from what he had

already achieved, which was hardly understood by anybody at the time, and employed the somewhat outdated Impressionist technique of painting in order to meet the expectations of his new artistic friends. He should not be reproached for that: like many other artists, he simply modelled his work on others he admired and experimented with various styles in the process. However, he would not have been Richard Gerstl had he not developed the corresponding aesthetics for his purposes along with derivative paintings of this kind.

INTENTIONAL PAINTING ERRORS

Gerstl is not interested in analysing a character in his portraits. Instead, he takes the situation of a figure in a specific space as the reason to experiment with colour, light and aesthetic techniques. The expression of the subject, therefore, usually ranges from unemotional to bored as is usual when anyone poses for a portrait. The only exception is the portrait of Arnold Schönberg, whom Gerstl showed as an intellectual (fig. 8). Schönberg was the artist whom Gerstl admired most among his contemporaries and he clearly wanted to impress him. More than any other person in Vienna, Arnold Schönberg had separated himself so decisively from the traditional goal of art to create something "beautiful", and this is how Gerstl depicted him. Klaus Albrecht Schröder is correct when he writes about the "rapid movement" of the sofa and wallpaper towards the front left and the "stressed diagonal pull" that forms a moving counterpart to the marked tranquillity of the composition and "determines the quality of the Schönberg portrait".[7] Only the composer's hands and face protrude plastically from the surroundings into which Schönberg's dark brown suit merges chameleon-like, because even the clothing is shown in two-dimensional fashion as in a wood cut; the immense effort needed to break away from the bourgeois, closed environment of the time and become an authentic innovator makes itself felt in the head, face and hands.

It is an imperious, defiant, self-confident insistence on the self that occurs here. Gerstl also made the precariousness of an artistic existence of this kind perceptible and did so by intentionally making a painting error. This can only be seen on the original, since the uncertainty of the image construction is weakened in reproductions. The room, marked by the lines of

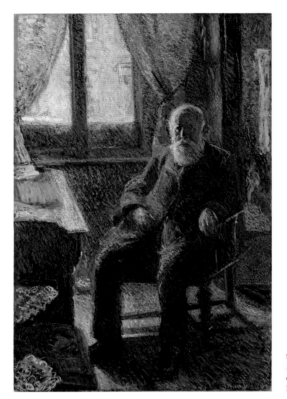

9 *Portrait of the Father
Emil Gerstl*, 1906, oil on
canvas, 211.1 × 150.3 cm
Leopold Museum, Vienna

the sofa, wallpaper and parquet, breaks off to the left front into nothingness
outside the borders of the painting. Only the artist resists this downward
movement and, in this way, becomes a guarantor that the world does not
fall out of balance.

COLOUR AS A BEARER OF ENERGY

Gerstl's life took a decisive turn through the intense contact with Mathilde
and Arnold Schönberg and their artistic circle. His loneliness was eased
and his new acquaintances provided him with the reactions to his work
that are so important for an artist. The respected composer and his wife

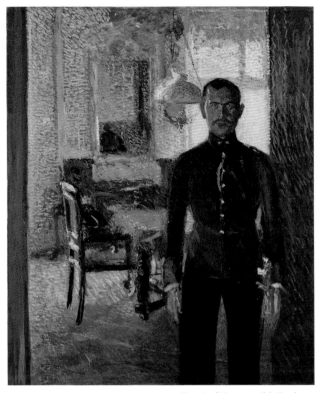

10 *Portrait of Lieutenant Alois Gerstl*, 1906
Oil on canvas, 153 × 130.2 cm, Leopold Museum, Vienna

even took painting lessons from him. For a period – from spring 1906 to before the summer of 1907 – Gerstl, as already mentioned, reverted to a kind of Impressionist technique with which he wanted to be successful and which actually did make an impression.

However, it soon became clear that he was extending the rules, subordinating them to goals other than reproducing an optical impression, and that he finally left them completely behind him.[8] It is characteristic that the most important works from this phase were created without a commission: the *Portrait of the Father Emil Gerstl* (fig. 9) and the *Portrait of Lieutenant Alois Gerstl* (fig. 10). Both paintings show a resolute break with the severely divisionist method of colour separation and turn to a conception of the space as a light event and of colour as a flow of energy. To

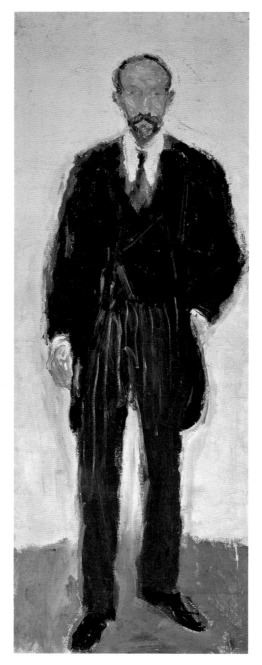

11 *Prof. Ernst Diez*, before 1907
Oil on canvas, 184 × 74 cm
Belvedere, Vienna

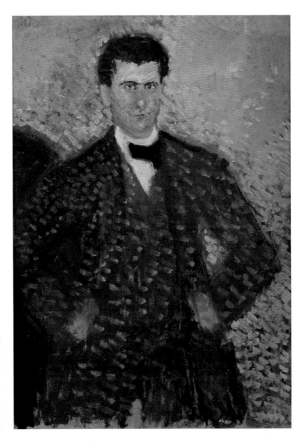

achieve this, Gerstl liked to make use of back lighting streaming in through a window in the background and the resulting contrast of light and shadow. At the same time, this artistic project made it possible for the spots and strokes to produce longer and formally more irregular and more energetically charged colour lines.

It is only logical that the borders of the contours of the figures begin to dissolve. The bodies become more transparent, almost disembodied, and the light more invasive. The portrait of the art historian *Prof. Ernst Diez* (fig. 11) is a good example of this, as is the self-portrait that brings this phase to a close and in which the light whirls over the entire room as particles of colour (fig. 12).

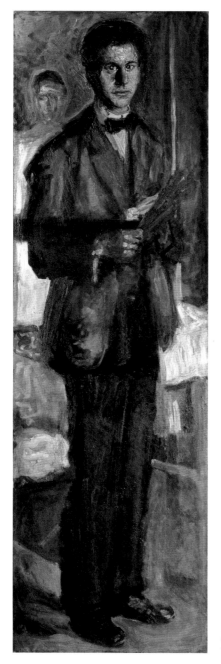

13 *Self-Portrait with Palette,* 1907
Oil on canvas, 186.5 × 58.5 cm
Wien Museum, Vienna

Seen from the aspect of the development of Gerstl's painting technique, we can ascertain that the Seurat-like dots and patches of paint have become dynamic strokes that cause the energy of the colour concerned, rather than its simple phenomenality, to shine. Karl Albrecht Schröder sums it up well when he writes that neo-Impressionism was "reinterpreted as a dynamic light event in Gerstl's painting culture."[9]

THE PSYCHOLOGY OF THE DOUBLE MEANING

The various versions of the self-portraits Gerstl put on canvas during the 1906/07 winter show the established artist in suit and bow tie. This is probably an indication of the optimism that had entered Gerstl's life as a result of being accepted into the Schönberg family and their circle in such a friendly way. However, at the same time, Gerstl makes it absolutely clear that this bourgeois man has not lost the inner contact to his own person that crossed conventional borders.

The *Self Portrait with Palette* (fig. 13), which seems – at first sight – to be so peaceful, occupies a temporal and artistic position between the emphatic eruption of 1902/03 and the despairing self-portrait painted in September 1908. On the one hand, the artist pays distanced attention to himself here in his role as his own model but, on the other, quotes the earlier semi-nude, that subversive self-image that takes the position of a latent transgression of boundaries, in the background. In this way, the impression of a rather bland self-portrait of the artist is transformed into a constellation with a double meaning. The slightly squinting, restlessly challenging gaze of the artist suggests itself as the overall statement of the painting.[10]

The artist constructs the various spatial levels with great skill and reality begins to totter in the intermediate spaces. The viewer himself takes up the position of the mirror into which the artist is gazing so searchingly. The artist shows himself to be a depth psychologist by placing the semi-nude in the background – not in the Freudian sense, though, because the semi-nude is neither a symbol of the id or superego, but of the deeper, elevated self. His gaze forces its way through the viewer's shell to reach his hidden, naked – and possibly unlived – essential existence.

Once again, this is not a painting that can be looked at "with disinterested pleasure". Quite the contrary: it causes the viewer to question himself.

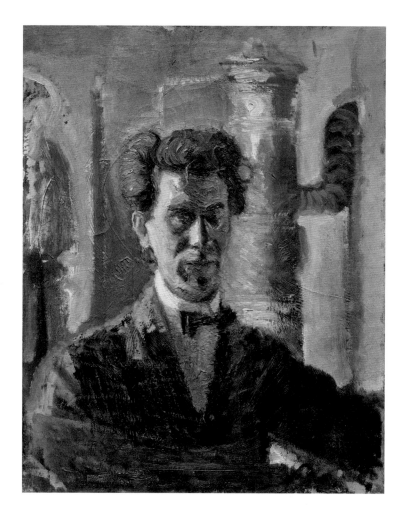

14 *Self-Portrait in Front of the Stove*, 1907
Oil on canvas, 69 × 55 cm, Private Collection

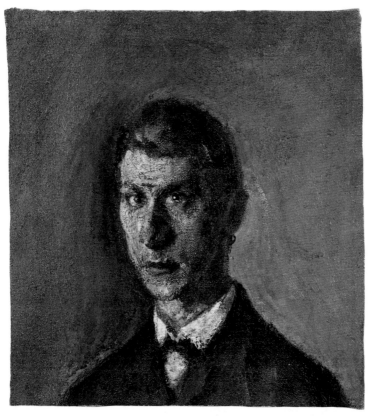

15 *Self-Portrait*, 1906/07, oil on canvas,
41.7 × 39.2 cm, The Leopold Private Collection

Gerstl's characteristic gaze – enigmatically questioning, intimidating – can also be observed in almost all of his self-portraits (frontispiece p. 8, figs. 14 and 15). The fact that the eyes are characterised differently in each one of them is not a unique distinguishing feature but can also be seen in self-portraits by other artists. The difference between the two eyes almost seems to be a prerequisite for art: fluctuating between oblivious confluence and coolly evaluating detachment. Thereafter, the picture-within-the-picture references in other portraits by Gerstl, are also symptomatic of the existence of a double meaning that threatens the illusion of a stable ego (figs. 16 and 17).

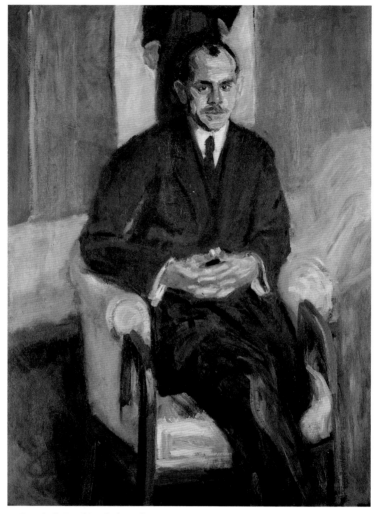

16 *Portrait of a Seated Man in the Studio*, 1908
Oil on canvas, 130 × 100 cm, Private Collection

17 *Seated Woman in a Green Blouse*, 1908
Oil on canvas, 180.5 × 85.5 cm, Leopold Museum, Vienna

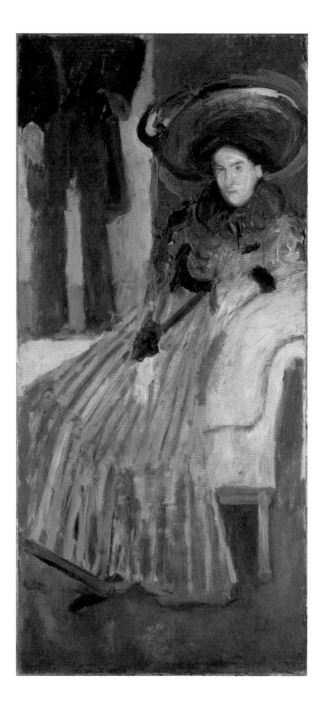

DISPLACEMENT OF THE CENTRE OF PERCEPTION

Gerstl saw himself compelled to position a very definite provocation through his artistic work: namely, that of thinking seriously about where the true centre of perception should be placed. This appears to be the reason that he violated the traditional rules of painting and the aesthetic desires of his time and society.

In the summer of 1907, Gerstl selected the landscape as the medium for his artistic investigations – in this case, the foothills of the Alps in the area around Lake Traun in the Salzkammergut region where he spent the summer close to the Schönberg family in 1907 and 1908.

The small-format vistas across the lake, and especially the garden world with their dominant green tones, make it possible to understand his path towards a completely new form of Expressionism that increasingly led further away from the subject and more into the phenomenon. The leading question is how, when awakened and given life by artistic perception, the particular object – the plant, the landscape or the person – is composed in itself and how the artist can transfer this interconnection between the intensity of perception and the quality of the object to the canvas.

In other words, and from the viewer's perspective, the location from which the picture is experienced moves from the distance *in front of* the picture *into* it – a position that would become the subject of further study for other artists and artistic movements in the twentieth century.

GARDENS AND LANDSCAPES

Gerstl developed the open expressive art necessary for questions of this kind in the few months between the spring and the middle of the summer of 1907. The oil sketch *Fruit Tree with Wooden Supports* (fig. 18) continues to breathe the French spirit of the decomposition of the light into moments of colour, but we already feel the emancipation of the object in this work: the strokes of colour seem to explode. The artist still depicts the lower half

18 *Fruit Tree with Wooden Supports*, 1907
Oil on canvas on cardboard, 35.5 × 20.5 cm
Kamm Collection Foundation, Kunsthaus Zug

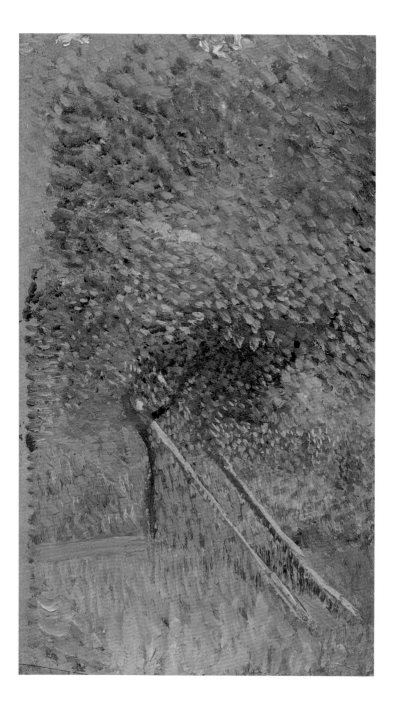

19 *Lakeside Road near Gmunden*, 1907
Oil on canvas, 32.3 × 33.2 cm, Leopold Museum, Vienna

20 *Country Garden with Fence*, 1907
Oil on canvas, 36.7 × 51.2 cm, Leopold Museum, Vienna

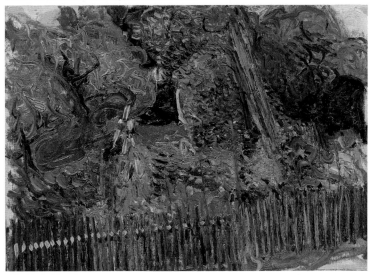

21 *Flowering Meadow with Trees*, 1907
Oil on canvas on cardboard, 36 × 38 cm
Kamm Collection Foundation, Kunsthaus Zug

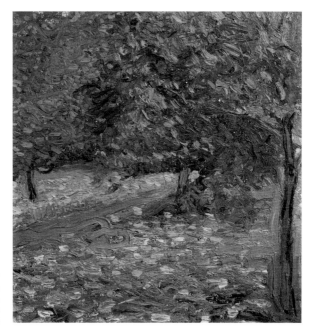

22 *Orchard*, 1907
Oil on canvas, 35 × 34 cm
Private Collection

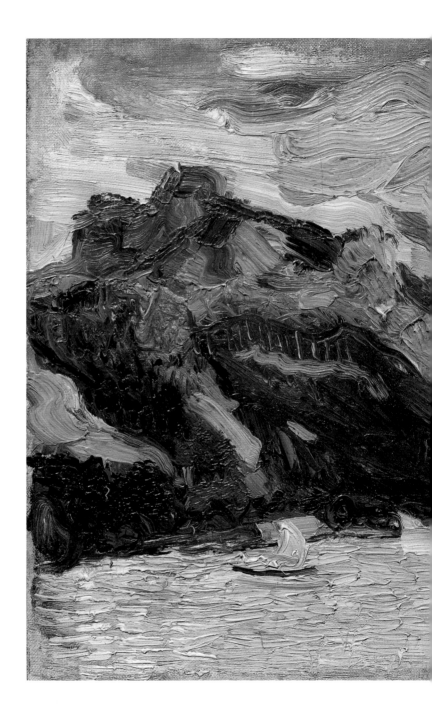

23 *Traunsee with Mountain*
"Sleeping Greek Woman", 1907
Oil on canvas, 37.7 × 39.3 cm
Leopold Museum, Vienna

of the painting from a distant point of observation while, in the upper section, he appears to have moved into the object, into the treetop, in a manner of speaking. Through this confluence with the world, the object ceases to exist and shows much more – here albeit only rudimentarily – the atmosphere of this moment in which, potentially, the artist and landscape become indistinguishable from each other.

Of course, in this case, landscape painting per se is at stake and Gerstl experiments with this new aspect in a variety of ways that show more or less confluence, more or less recognisability. In this way, the representation of the landscape is taken to its limits; it goes to the extreme and creates the impression of a mixture of light and colour.

Works such as *Lakeside Road near Gmunden* (fig. 19) and *Country Garden with Fence* (fig. 20) occupy a kind of midway position between depicting concrete objects and penetrating into the unity of the subject and world in an encompassing colour situation. In paintings such as *Flowering Meadow with Trees* (fig. 21), *Orchard* (fig. 22) and *Tree with Houses in the Background* (fig. 1), on the other hand, the tendency towards interconnection is already clearly perceptible. That not only the intimate, narrow view into the green stands as the medium for defeating the subject-object boundary is shown, for example, in the energetic composition of strips of colour in *Traunsee with Mountain "Sleeping Greek Woman"* (fig. 23) in which the massif and the turbulent sky partly show identical structures; they therefore converge in a homogenous space that is simultaneously the space of the artistic awareness.

ENDLESSNESS OF THE MOMENT

The unequalled peak of this artistic experiment – the moment when this stops being an attempt and becomes a success – was reached by Gerstl with his small-format painting *Sunny Meadow with Fruit Trees* (fig. 24): a milestone in his art through the simultaneous disappearance of the subject and the world in a multifaceted structure full of nuances that nevertheless still evokes the immediate feeling for Nature. Here the subject and world still exist in a way that can be felt within, however without a distancing ego and without a discretely contoured object. It is probably not coincidental that the circle around Gerstl described this painting as the "spinach landscape".

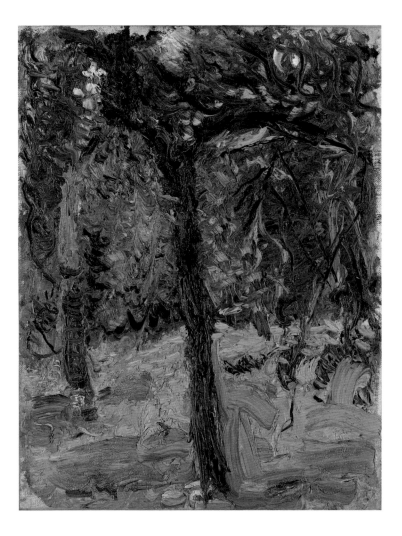

24 *Sunny Meadow with Fruit Trees*, 1907
Oil on canvas, 44 × 34.7 cm, Leopold Museum, Vienna

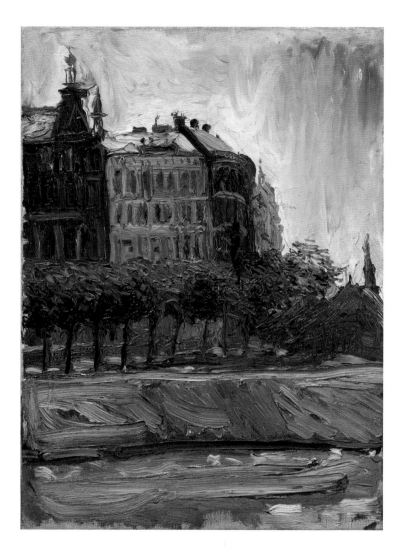

25 *On the Danube Canal*, 1907
Oil on canvas, 63.5 × 47.5 cm, Leopold Museum, Vienna

The usual concept of art created a constellation of the artist and viewer on the one side and the picture, which is separated from the two, on the other. The vegetal metaphor stands in opposition to this. "Spinach art" is not there to be looked at; it is there to be absorbed. However, in this process of artistic realisation, it is unclear who or what pulls whom or what into his or its world…

The Gerstl scholar Raymond Coffer appropriately writes of these landscapes that the synthesis of their nuances evokes a kind of "boundlessness"[11] – and the subject and world becoming interlocked which can be interpreted from Gerstl's artistic intention, actually bears an endlessness of the moment within it.

VISUALISED AMBIVALENCE

Richard Gerstl returned to Vienna at the end of the summer of 1907. He used what he had achieved on Lake Traun in paintings of the urban landscape of Vienna (fig. 25).

However, the artistic freedom he had found did not mean that there were no dark personal feelings. He actually had to be treated for a "nervous stomach" complaint in the autumn of that year. It cannot be stated with any certainty that this was a bipolar, manic-depressive illness as various sources have claimed.

Nevertheless, the Romantic notion of the tragic artist left its mark on the interpretation of his paintings. Gerstl's *Self-Portrait Laughing* (fig. 26), painted in what are actually warmly-glowing colours, does not show him in complete despair, as people would like to see artists in general; nor does it show him in a state of oblivious joy, as less-narcissistically-inclined people tend to be. Gerstl was obviously aware of similar paintings, including works by Rembrandt, but he transports the situation into the arcane. It can be said that, here, Gerstl possibly demonstrates a threat to the limits of the subject, to a psychological instability, that becomes clear through the different expression of the cheerfully contorted mouth and the eyes drifting off in solitary coldness. However, it is not possible to interpret this painting in a one-sided manner. In its interconnection between psychology and spatial depiction, this small masterpiece is possibly a sign of a liberated inner situation following a successful artistic coup.[12]

ENDOGENOUS EXPRESSIONISM

We can recognise an analogous development towards a new kind of expressive art in the series of portraits as well as in the landscapes. One-and-a-half years after the first post-Impressionist portraits and barely one year after the homogenisation of the space in his landscapes and urban paintings, Gerstl also makes use of the diffusion of the centre of perception in his portraits.

The *Portrait of Henryka Cohn* (fig. 27) marks the first decisive step in this direction. If this expressive portrait is compared with one that goes "completely against its grain" in a manner of speaking – Gustav Klimt's *Fritza Riedler* (fig. 28) – the distance the contemporary Gerstl had covered becomes obvious. In Klimt's work, the worlds of the ornaments, dress and flesh stand alongside and against each other – a critical commentary that is, however, located on this side of the beautiful appearance. On the other hand, in Gerstl's portrait of Henryka Cohn, the patterns of the material, dress, skin, face, background and the woman's gaze all entwine. Reality is created through the medium of human perception – whether it is the painter's or that of the person being portrayed is consciously left open. In the concrete situation, both perspectives come into an aesthetic differential that could be called "endogenous Expressionism": the visualised expression comes from within the participating persons and factors.

DELIMITATION AND UNIFICATION

In 1908, Gerstl once again followed the Schönbergs to Lake Traun and took his experiments in the medium of the portrait to the extreme during this summer. The paintings *Couple in the Field* (fig. 29), *Portrait of Alexander von Zemlinsky* (fig. 30) and *Mathilde Schönberg in the Garden* (fig. 31) mark stations on the path to a tendentially non-representational form of colour painting.

However, the artist still remains on this side of the canvas as an observer of the phenomena of light. He looks onto the situations that open up as spaces of colour and where the people seem to melt into their surroundings. Here, the often noted folded-up floor, which takes up the position of the open horizon, plays a significant role. However, it is not simply the

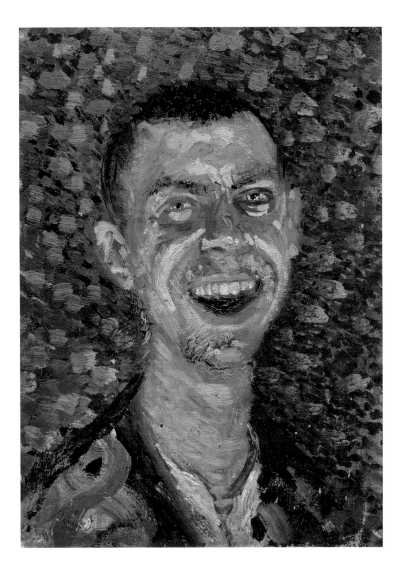

26 *Self-Portrait, Laughing,* 1908
Oil on canvas, 40 × 30.5 cm, Belvedere, Vienna

27 *Portrait of Henryka Cohn*, 1908
Oil on canvas, 147.9 × 111.9 cm, Leopold Museum, Vienna

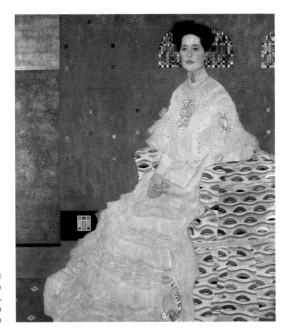

28 Gustav Klimt
Fritza Riedler, 1906
Oil on canvas,
153 × 133 cm
Belvedere, Vienna

surrounding space that closes itself homogenously here; it is simultane-
ously the awareness of the artist that, doubled as it were, once again en-
closes the figures from behind. In this way, the unnatural raising of the
horizon is a further step into the picture. Here, the delimitation of the
figures and the unification of the experiential space that encloses the
centre of perception are simply two sides of one and the same coin.

ATONALITY AND ABSTRACT PAINTING

It is not possible to determine seriously what triggered the decisive next
step. Some interpreters make a supposedly manic phase responsible for
this; others feel that it was the close cooperation with his composer friend
Schönberg who was working on his *Opus 10* and, with it, on the verge of
crossing the border to so-called atonality.
Although it is astonishing that the two artists overstepped the threshold
of the conventional almost simultaneously in July 1908, it should not be

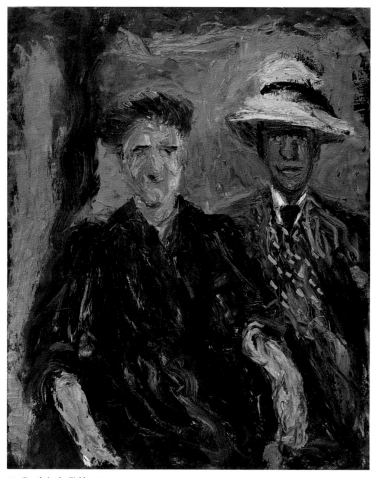

29 *Couple in the Field*, 1908
Oil on canvas, 111.2 × 90.7 cm, Leopold Museum, Vienna

forgotten that they had both prepared and developed this step into new
territory through years of consideration and modification of the individ-
ual artistic medium of each. The opinion that each artist motivated the
other to search for freedom and that, in each other, they found what is so
important, almost indispensible, for creative work – namely, understand-
ing and recognition – most likely comes closest to the truth about the
creative process.

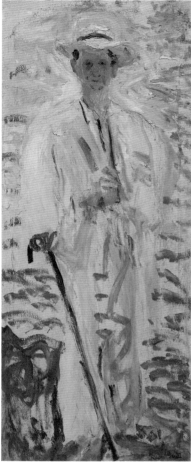 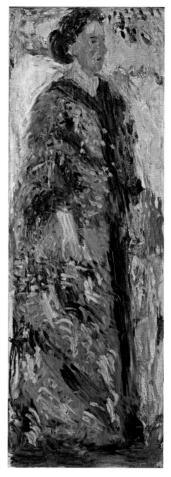

30 *Portrait of Alexander von Zemlinsky*, 1907
Oil on canvas, 170.5 × 74.3 cm, Kamm Collection
Foundation, Kunsthaus Zug

31 *Mathilde Schönberg in the Garden*, 1908
Oil on canvas, 171 × 61 cm
Leopold Museum, Vienna

In any case, Gerstl reached a radical formulation of his search in three
pictures he painted in the second half of July 1908 (figs. 33, 34 and 35).
Although there were probably more, at least these three have been pre-
served. Gerstl stored most of his paintings with a farmer's family, and they
simply threw them away later. And who could blame them for that? The
aesthetic of what Richard Gerstl had accomplished was too new for it to be
recognisable as art.

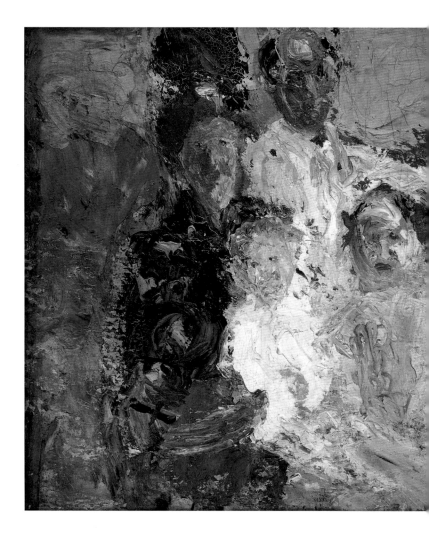

THE SCHÖNBERG FAMILY

Here, Gerstl did not remove himself entirely from the concrete reality of the situation but totally reversed the line of vision of the painting: away from an outside position and into the core of the situation and people shown and, from there, once again out to the visible (fig. 32). Finding a language that develops from within the other and not vague external

32 *The Schönberg Family*, 1907
Oil on canvas, 88.8 × 109.7 cm
Museum Moderner Kunst Stiftung Ludwig Wien
Donation of the Kamm Family, Zug

similarities is decisive here. The dynamic, colourful emanation is the phe-
nomenon, not the surface and contour. However, if one takes part in this
reversal of the line of vision, what is "depicted" once again becomes much
clearer: Mathilde's warm nature, Arnold's intellectual nature, the inno-
cence of young Georg, the vulnerable joie-de-vivre of the daughter
Gertrud – a truly radical "family portrait".

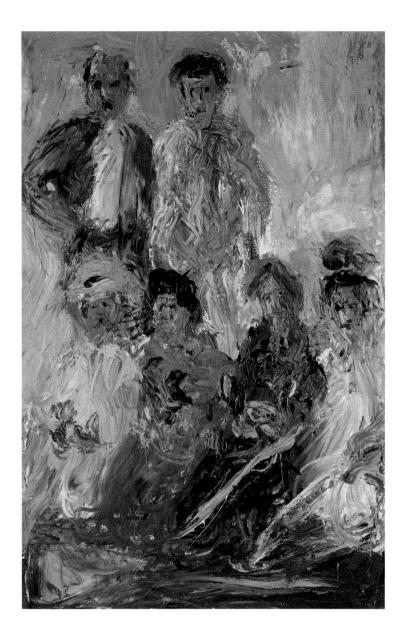

33 *Group Portrait with Schönberg*, 1907
Oil on canvas, 169 × 110 cm, Kamm Collection Foundation, Kunsthaus Zug

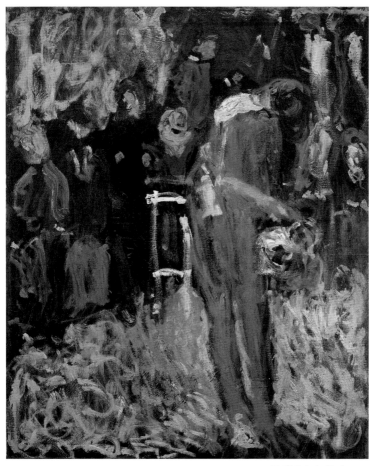

34 *Nude in the Garden*, 1907
Oil on canvas, 121 × 99 cm, Private Collection

GROUP PORTRAIT WITH SCHÖNBERG
AND *NUDE IN THE GARDEN*

———

Gerstl went even further with his group portrait of his friends and col-
leagues (fig. 33). He not only used the brush, but also his hands and fingers
when he hurled paint onto the canvas and smeared it. He must have given
the impression of being a person suffering from a manic episode.[13] Of
being an artist who went beyond merely exercising his art and actually

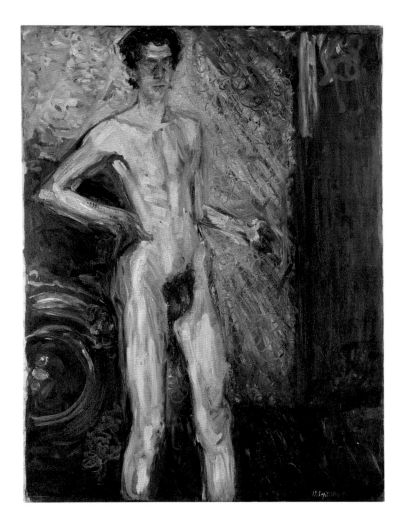

35 *Nude Self-Portrait with Palette*, 1908
Oil on canvas, 139.3 × 100 cm, Leopold Museum, Vienna

lived it. Of not depicting an impression but of embodying an energetically experienced moment of the world.

In consequence of this, in the next painting he shows himself completely naked in an existential and aesthetic-creative sense. (fig. 34) It would take more than half a century for what Gerstl had achieved here to be taken up by the Vienna Actionists and carried further by using their own bodies instead of a canvas.

We do not know what else the young man painted in that summer of August 1908 on Lake Traun. In any case, the love affair between him and Mathilde Schönberg took on all too visible contours. The fact that Gerstl's next step was the one into life itself may have resulted from some form of inner logic.

KING OEDIPUS

The social scandal, the exposure of the affair between Richard and Mathilde, and the personal catastrophe when she returned to her husband after only a few days lie between the group portraits painted in the summer of 1908 and *Nude Self-Portrait with Palette* (fig. 35), the important self-portrait of Gerstl from September of the same year. Strangely, the artist dated the painting following these events: 12 September 1908. The existentially dangerous situation made itself felt immediately and with great vehemence: deep suffering and resignation at being about to be obliterated.

The artist achieved this strong, immediate effect through the powerful painting technique used to depict his body and the way in which he shaped the spatial situation as a doubling of the same statement. While the body functions as the medium of the spirit in the self-portrait from 1902/03, here the human existence is in danger of being reduced to a purely organismic event: Ecce homo!

The artist props his arm self-confidently against his hip and shows himself completely naked. His liberty is a liberty to which he is damned. The body is emaciated, pale and frail. Only the genitals have plasticity. The painting is in no way naturalistic. The colours develop out of the overall mood, the contour is deformed and the entire work is penetrated by expressiveness and psychological elements.

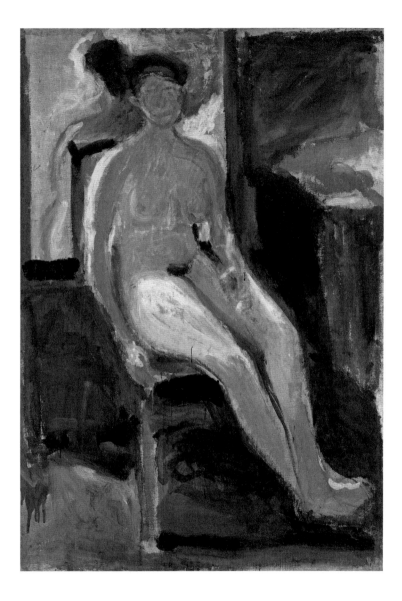

36 *Seated Woman, Nude,* 1908
Distemper on canvas, 166 × 116 cm, Leopold Museum, Vienna

The background intensifies the despairing, floundering spirit of existence. In contrast to the early self-portrait, reality restricts the space of the artist-ego and, at the same time, is perceived subjectively in a very specific manner. The pallid, broad brushstrokes that mark the body, the shadowed eyes and the wild, circular squiggles of the wallpaper reveal a tendency towards dissolution that interlocks the inner and outer and severely threatens any stability. Pictorially speaking: a garden that has fallen prey to neglect with a tree that has been stripped of its bark in the middle of it, and with a decayed fruit hanging from it… – a modern King Oedipus.[14]

A WARM LIGHT

Despite its feeling of hopelessness, this last self-portrait most probably does not mark the end of Gerstl's creative life. Hardly one month later he was obviously determined to continue. He rented another studio and moved his belongings from the old apartment next to the Schönbergs' home to his new abode. At first, it appeared that life would go on.

And it appears that Mathilde also visited Richard in his new studio. After the artist had taken his life, she wrote a letter to his brother Alois requesting that any of her possessions that might be found there not be returned but destroyed – probably afraid that Arnold would recognise that she had once again taken up her relationship with the younger man. It seems highly likely that Mathilde also posed nude for Gerstl in this studio: *Seated Woman, Nude* (fig. 36).

Once again, it is necessary to sit in front of this painting for some time to be able to grasp its deeper qualities and feel the warm aura of the woman's body that the artist provides us with through his lover. A quiet smile can even be seen on the original, but this is difficult to make out in a reproduction.

THE VOODOO OF THE MUSICIANS

It seems probable that Richard made a marriage proposal to Mathilde at the beginning of November 1908. In this way, he set both of them an ultimatum. Mathilde rejected him and went back to her young children.

It was this second and final decision that left Richard absolutely empty. He had not only lost the person closest to him but the circle around Arnold Schönberg also turned their backs on him. On 4 November 1908, Schönberg's group of musicians organised a concert for personally invited guests. Gerstl was intentionally excluded. At the time when the concert was taking place, Gerstl burned compromising private documents and then hanged and stabbed himself to death.

SENSE AND SENSUALITY

Richard Gerstl had no pupils and no immediate successors and was soon forgotten. In the early 1930s, after he had been made aware of the œuvre by the artist's brother Alois, Otto Nirenstein (1894–1978), the later Otto Kallir of Gallery St. Etienne in New York, presented works of the unknown artist to an astonished audience in his Galerie nächst St. Stephan in Vienna. However, the Nazi period and the Second World War prevented any lasting impact being made.

It was not until the 1950s that several enthusiastic collectors and art historians called for a re-evaluation of Gerstl's work, so that it could be given its due esteem. The principal proponents were Otto Breicha (1932–2003)[15] and Rudolf Leopold (1925–2010). The latter's foundation, the Leopold Museum, now houses the world's largest Gerstl collection.

People became aware of Gerstl and recognised important developments in his work. The dissolution into free, but highly emotional, colourfulness was echoed in paintings by Lovis Corinth, Chaim Soutine and Herbert Boeckl and, after 1945, in American Expressionism – Willem de Kooning is one example – as well as Frank Auerbach and Georg Baselitz, to name only a few. Using his own body image made Gerstl, together with Schiele, a source of inspiration for the Viennese Actionists, especially Günter Brus and Otto Muehl. On the other hand, in the late 1970s, the group of so-called "New Wild Painters" in Berlin took up his gestures of artistic subjectivity and independence.

However, it should not be overlooked that Gerstl found his own, unique, solutions that have hardly ever been equated by any other artists. When he was referred to at a later time, the results were usually more conventional, coarser and more superficial. In contrast to these, and similar to the

greatest artists of all periods, Gerstl considered reconciling diametrical differences – showing both the external appearance of light and inner qualities that are less visible and more perceptible; starting out from the inner, abstract experience of a situation without abandoning the connection to its reality, uniting sense and sensuality – as a fundamental part of his calling.

Slowly but surely, Gerstl's pictorial solutions and his radical artistic search – and the fact that he did not allow himself to be put off the track while on this search – are coming to the attention of people for whom art has a meaning. It is no longer possible to ignore him.

DIETHARD LEOPOLD *(b. 1956) is the son of the art collector Rudolf Leopold and studied German, Theology and Psychology at the University of Vienna. Leopold worked as a psychotherapist (Gestalt therapy) in Vienna and has been the Curator of the Leopold Museum there since 2008. He has curated numerous exhibitions and has published books and catalogue contributions, especially on the topic of art and culture in Vienna in around 1900.*

1 In short, this is the psychological teaching of the then influential physicist, philosopher and psychologist Ernst Mach (1838–1916).

2 For biographical information, I generally use the findings given in the thesis by Raymond Coffer that, after the first books by Otto Breicha (1991, 1993 and 1996), are by far the most comprehensive and precise (Coffer 2011).

3 Leopold 2013, p. 77f. Gerstl was one of the first readers of *Traumdeutung/ Interpretation of Dreams* which was published in 1899 (Freud intentionally changed the date to 1900 to make it the first book of the new century).

4 Schröder 1996, pp. 48–50. The catalogue by the director of the Albertina, Klaus Albrecht Schröder, provides a wealth of well-judged analyses of Richard Gerstl's work, as well as interesting historical comparisons.

5 Leopold 2013, p. 81f.

6 Coffer 2011, p. 64ff.

7 Schröder 1996, pp. 54–56.

8 Here, I follow the stylistic analysis of Klaus Albrecht Schröder, who wrote his doctoral thesis on Gerstl's work and published his detailed findings in an exhibition catalogue (Schröder 1996). See also note 4.

9 Schröder 1996, p. 29.

10 Leopold 2013, p. 82f.

11 Coffer 2011, pp. 159–160.

12 Coffer 2011, p. 154f.

13 Coffer 2011, p. 264ff.

14 Leopold 2013, p. 84ff.

15 See Breicha 1991; 1993 and 1996.

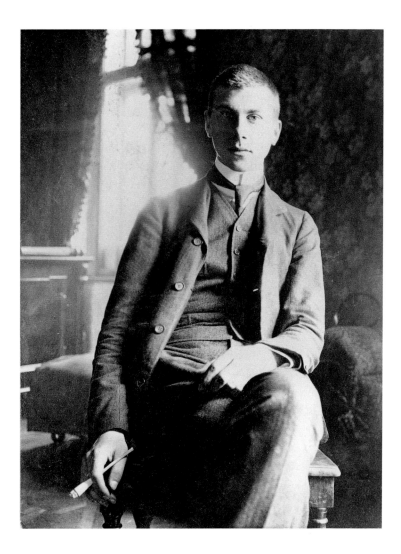

37 Richard Gerstl, ca. 1905

BIOGRAPHY

Richard Gerstl
1883–1908

Compiled by
Birgit Summerauer

1883–1897 Richard Gerstl is born in Vienna on 14 September 1883 as the third child of Emil (1834–1912) and Maria Gerstl (née Pfeiffer; 1857–1910). The parents only married on 26 August 1883, shortly before the birth. Richard's older brothers August (1880–1945) and the later chronicler of Richard's life, Alois (1881–1961), were born out of wedlock. The reason for the late marriage can be found in the couple's different confessions: Emil Gerstl was Jewish and Maria Pfeiffer, Christian. Although the marriage took place in the Israelite Temple in Vienna according to Jewish law, Richard was christened Roman Catholic.

The roots of Gerstl's father, a person of independent means, can be traced back to Neutra in what was then Hungary. The mother's family originated in Kaplitz near Budweis (České Budějovice) in today's Czech Republic. The father had amassed considerable wealth on the stock exchange and lived with his wife and children in bourgeois prosperity.

After attending primary school on Bartensteingasse in Vienna, Richard spends two years in the renowned Piarist Maria Treu School. Disciplinary problems lead to his changing to a private school on Buchfeldgasse where he completes the junior level. Richard starts taking drawing lessons from Otto Frey, a student at the Vienna Academy, while he is still at school and completes a two-month course in the Aula drawing school led by Ladislaus Rohsdorfer.

1898 Gerstl applies for admission to the Academy of Fine Arts on Schillerplatz in Vienna and – at only 15 years of age – is accepted into the most exclusive art school in the entire monarchy. Gerstl starts his studies in the general painting class of Professor Christian Griepenkerl, one of the main representatives of Viennese "Ringstrasse" painting, in October. Although Emil Gerstl does not approve of his son's artistic endeavours, he is prepared to finance his art studies.

1900/01 The relationship between the headstrong young student and the conservative professor is doomed from the very beginning. Gerstl has no success in the traditional art education of the period and is only given a mark of "satisfactory" in most subjects.

Disappointed at the teaching activities of the Academy, Gerstl attends Simon Hollósy's painting school in Nagybánya in former Hungary during the summer months of the years 1900 and 1901. In the years around the

turn of the century, the artists' colony was considered a place where modern artistic tendencies were transmitted and had developed into a popular meeting spot for young artists of many nationalities. Other Griepenkerl pupils who rebelled against conservative academism also attended this painting school.

1901 In summer, Gerstl – together with his fellow student Victor Hammer – leaves the Academy after three years of study. We can only guess as to whether Gerstl chooses not to continue his studies of his own free will or whether he is not accepted for the fourth year as his brother Alois reports.

1901-1904 Gerstl does not attend the Academy for three years. Although he still lives in his parents' home (Nussdorfer Strasse 35, in the 9th district of Vienna), Gerstl rents a room on Haubeniglgasse in Döbling, which he uses as a studio, and later space in the house of Therese Krones on the Hohe Warte. During these years he wants to be able to continue his studies of languages without being disturbed and also to devote himself to philosophy, literature and musicology. Gerstl reads works by Sigmund Freud and Otto Weninger and plays by Ibsen and Wedekind. He is extremely well-versed and eager to study the new phenomena of his time. Gerstl leads a secluded life and has few friendships. Most of his contacts are in Vienna's artistic circles. With his stubbornness in artistic matters and, occasionally, arrogant and elitist manner in dealing with other people, the young painter frequently meets with a lack of understanding. In addition to his family and Waldemar Unger, a childhood friend, Victor Hammer is one of his few close contacts. For some time – at the earliest in 1902 – the young painters attend the private art school run by Ferdinand Kruis at Kohlmarkt 1 in the centre of Vienna.

Very little of either Gerstl's academy studies or of his copying activities in the Kunsthistorisches Museum in Vienna has been preserved. The first works still extant today date from the year 1902. The revolutionary, large-format painting *Semi-Nude Self-Portrait* showing the artist with a naked torso and only covered with a loincloth was created in 1902/03.

In August 1904, a nervous stomach complaint forces Gerstl to seek treatment in the spa at Baden near Vienna.

1904/05 Gerstl starts attending Griepenkerl's class once again on 28 October 1904. However, as can be seen in the professor's evaluations, Gerstl's studies are even less successful than before and the only subject for which he is given a "satisfactory" mark is "diligence". After only two semesters, and following a disagreement with Griepenkerl, Gerstl is no longer allowed to participate in the 1905/06 winter semester.

Gerstl shares a studio at Gumpendorferstrasse 11 in Vienna's 6th district with Hammer, who changes from Griepenkerl's general painting class to the special class of Professor Heinrich Lefler. As a founder of the Hagenbund artists' association and representative of the "modern" in the teaching staff at the Academy, Lefler was regarded as being considerably more progressive and open than Griepenkerl.

1906 After a one-semester break, Gerstl starts studying again and, in March, also enrols at Heinrich Lefler's special school for painting. According to his brother Alois, Gerstl had a coincidence to thank for this: when Lefler visits his pupil Hammer, he notices Gerstl's painting *The Fey Sisters (Karoline & Pauline)* that was in Hammer's flat at the time. Gerstl accepts

Lefler's invitation to become a pupil in his class on the condition that he be given a studio of his own at the Academy. The relationship between Gerstl and Lefler is initially very good and amicable. The professor plans to exhibit Gerstl's works at the Hagenbund but then decides against this as he fears a scandal.

Gerstl was an enthusiastic concert- and opera-goer. In the spring of 1906, he makes the acquaintance of the composer Arnold Schönberg, who is still relatively unknown and much criticised at the time. Gerstl admires Schönberg for his modernity and resoluteness as a musician and composer. A friendly relationship ensues and Gerstl gives Schönberg and his wife Mathilde painting lessons.

Gerstl is accepted into the Schönberg circle, a dedicated group of people united in their admiration for Arnold Schönberg. This includes many who were composers or musicians themselves, as well as pupils of Schönberg's, who also gives evening courses in music theory. Among the people Gerstl meets here are Alban Berg and his sister Smaragda, as well as Alexander von Zemlinsky and Anton von Webern, with whom he exchanges views on musical and artistic positions and preferences at social gatherings. At this time, Gerstl considers accepting a job he has been offered as a music critic.

38 Richard Gerstl with his godfather Dr Karl Weihsböck, 26 May 1896

39 Lessons in Simon Hollósy's art school in Nagybánya

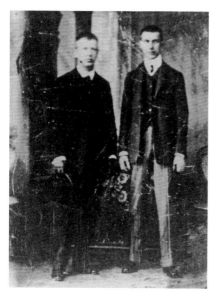

40 Richard Gerstl (right) and Victor Hammer

In the same year, Gerstl paints representative portraits of Schönberg and his wife Mathilde with their daughter Gertrud, of Smaragda Berg, and of the art historian Ernst Diez. In addition to important portraits, including those of his father and his brother Alois as a lieutenant of the reserve, he also creates many self-portraits. Gerstl paints his first surviving landscape in the northern environs of Vienna in spring. It clearly shows the influence of van Gogh (works by van Gogh had been displayed for the first time in Vienna in the Galerie Miethke at the beginning of the year).

1907 Gerstl is invited to spend the summer together with the Schönberg circle at Traunsee in the Salzkammergut region of Austria, where he discovers open-air and landscape painting as an important new subject. A great number of small-format landscapes of the area are the result. Gerstl enjoys Schönberg's complete trust and he often accompanies Mathilde to musical events in Vienna. Over time, the platonic relationship develops into a love affair and it seems that Arnold Schönberg becomes aware of this at an early stage. Otto Breicha quotes one of Schönberg's letters in which he exhorts his friend that: "Two men like us should not be driven apart by a woman." (Breicha 1993, p. 22)

Gerstl rejects a planned exhibition in the Galerie Miethke in Vienna on the grounds that he does not want his works to be shown alongside those by Gustav Klimt.

1908 Starting in February, Gerstl and Schönberg share a studio at Liechtensteinstrasse 68/70 in the 9th district of Vienna; Schönberg and his family live in the same house. Gerstl has no understanding for Lefler's involvement in the planned Jubilee Procession on 12 June 1909 to mark the 60th anniversary of the reign of Emperor Franz Joseph. In a confrontation on this matter, he reproaches his teacher saying that any artist who respected himself and his art would never become involved in such an event. Lefler, thoroughly annoyed, then demands that Gerstl leave the solo studio with which he had been provided by autumn and also does not display any paintings by Gerstl in an exhibition of works by his pupils in the Academy. This annoys Gerstl so greatly that he protests against the action in a letter written to the ministry in charge. The ministry forwards the letter to Lefler and the Academy where several professors read it. The affront exacerbates Gerstl's situation at the art school even further.

41 Richard Gerstl, ca. 1902

42 The Gerstl family's home was on the
first floor of the house at Nussdorfer Strasse 35
in the 9th district of Vienna

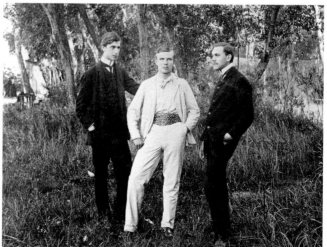

43 Richard
Gerstl, Waldemar
Unger and Alois
Gerstl (from left
to right),
after 1900

Gerstl once again travels to Traunsee with the Schönberg circle. The Schönbergs live in the Hois'n Wirt Hotel in Gmunden and – as in the previous summer – Gerstl has his lodgings in the Prillinger family's Fera Mill. Gerstl reaches the limits of the representational with the paintings he creates here – *Mathilde Schönberg in the Garden*, *Group Portrait with Schönberg* and *The Schönberg Family*.

The scandal escalates during the summer holiday at Traunsee: on 26 August 1908, Schönberg discovers his wife and Gerstl in a compromising situation. Mathilde immediately leaves her husband and travels back to Vienna together with Gerstl. Schönberg also breaks off his summer holiday and returns to the capital where he even instructs the police to look for his wife. After only a few days, Mathilde returns to her husband and two children.

It is clearly impossible for Gerstl to continue using his studio at Liechtensteinstrasse 68/70 and he moves into a new one at Liechtensteinstrasse 20 – also in Vienna's 9th district and not far from the Schönbergs' home – on 18 October 1908. Although Mathilde assures her husband of her remorse, she continues her affair with Gerstl until his death and visits him in his new studio. According to Alois Gerstl, the *Seated Woman, Nude* is a portrait of Mathilde whose face Gerstl later paints over so as not to discredit her.

We do not know why Gerstl rejects the offer of a solo exhibition proposed by Dr von Wymetal, President of the Ansorge-Verein (a society for the promotion of modern art). For Gerstl the affair results in the loss of all of his connections to the Schönberg circle, which completely avoids him following the scandalous incident. This rupture drives Gerstl into social isolation.

On the evening of November 1908, Gerstl commits suicide by hanging in his studio on Liechtensteinstrasse. It is said that, first of all, he rams a knife into his chest. Before taking his own life, he burns documents and compromising letters but no works of art. It could be accidental that, on the same day, a concert with music by Schönberg, Webern and other pupils is being performed by the Tonkünstler Orchestra in the main hall of the Musikverein in Vienna to which Gerstl is demonstrably not invited, but – psychologically – the coincidence as regards timing is certainly striking.

A few weeks before his suicide, Gerstl paints the radical *Nude Self-Portrait with Palette*.

44 Richard Gerstl, 1904

45 Professor Heinrich Lefler

46 Mathilde and
Arnold Schönberg, 1907

Richard's family, afraid of a scandal, does all it can to keep the reasons behind their son's suicide a secret. At the express wish of the family and Arnold Schönberg, very little information is provided in order to defend the honour of those involved and protect them from any journalistic investigation. A medical declaration of non compos mentis issued on 5 November makes it possible for Richard Gerstl to be given a Christian burial in spite of his having committed suicide. He is laid to rest in Sievering Cemetery in Vienna on 7 November.

After Lefler refuses to exhibit Gerstl's works in the Hagenbund, the works found in Gerstl's studio are removed from their frames, inexpertly packed in crates and stored at the Rosin & Knauer haulage company. Richard Gerstl is forgotten. It was not until 1931 that Alois Gerstl shows the art dealer and owner of the Neue Galerie, Otto Nirenstein, works by his brother. Nirenstein – who was later known as Otto Kallir – recognises the artist's exceptional talent and organises the first exhibition of Richard Gerstl's works in the same year. This is shown not only in the Neue Galerie in Vienna, but also in Munich, Berlin, Cologne, Aachen and Salzburg. However, the Nazi period and the Second World War prevent them from having any lasting impact. Gerstl is subsequently rediscovered by the art historian Otto Breicha and art collector Rudolf Leopold in the years after 1945 but it was only decades later that Richard Gerstl's real artistic significance became recognised internationally.

47 Richard Gerstl in his studio, ca. 1907/08

48 Richard Gerstl painting on the shore of the Traunsee; probably summer 1908

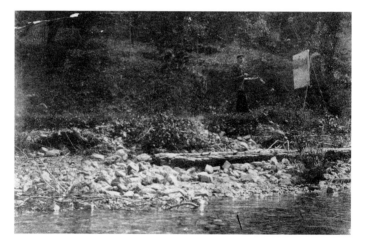

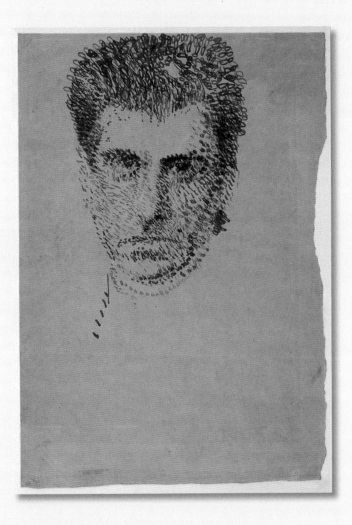

Self-Portrait, 1907, brush in black,
44.9 × 31.4 cm, Albertina, Vienna

ARCHIVE

Discoveries, Letters
1906–1908, 1954

Compiled by
Birgit Summerauer

I

On 22 July 1908, while he was summering in Gmunden, Richard Gerstl wrote a letter of complaint "To the Ministry of Culture and Education":

I have been a student at the special school led by Professor Lefler at the Academy of Fine Arts for the past five semesters. Not a single painting of mine was on show at the <u>school exhibition</u> that opened on the 19th of this month. The aim of this exhibition is to give an account of the achievements of each student and I would have been even more justified in having my pictures exhibited seeing that Prof. Lefler made the following statement about me to one of my colleagues: <u>He (meaning me) is following completely new paths; it is difficult to understand him, but there is nothing I can do for him.</u>["]

By not exhibiting my pictures without my knowledge and agreement, I was excluded from the competition for the special school prize that was awarded to Mr Ignaz Schönfeld: Prof. Lefler told me repeatedly, most recently only 4 weeks ago, that this student was <u>completely lacking in talent</u>. Seeing that I do not recognise the rector of the Imperial Academy as any <u>kind of authority</u>, I request that the Ministry of Education compensate me for this course of <u>action, which is definitely more than incorrect</u>.

Richard Gerstl, currently at Traunstein 18, near Gmunden

Prof. Lefler made the remark about me mentioned above to Mr Victor Hammer.

Gerstl waited in vain for a reply. On 20 August, his letter was forwarded to Heinrich Lefler who, along with Professor Hans Bittelich, signed it as "read". However, the letter was handled by Siegmund l'Allemand, the Rector of the Academy at the time. He had the letter filed unanswered on 6 September seeing that "if only because of its extremely inappropriate form, it [deserves] to receive no attention and no further action will be taken". It is possible that, after this affront, Lefler initiated steps to be taken against his pupil. However, there is no proof that Gerstl was expelled from the Academy as his brother Alois reported.

I Gerstl's letter of complaint to the Ministry of Culture and Education dated 22 July 1908

2 *Self-Portrait*, 1908, brush in black, 40 × 29.7 cm, Albertina, Vienna

1 2

2

Richard Gerstl's œuvre of drawings is very small. A mere eight drawings – all of them self-portraits – have been preserved. They were probably created in the years from 1906 to 1908. It is likely that Gerstl created more works on paper but, after his death, only the oil paintings were packed and stored at the Rosin & Knauer haulage company. The drawings, on the other hand, remained in the family and were lost over time or destroyed – as was the case with those created during Gerstl's stay on Traunsee in 1908, that were left with the Prillinger family in the Fera Mill.

Four of the works on paper we have today are in the Pointillist style and were created around 1906/07. Gerstl diversified the distribution of light and shadow on the sheets through the use of variously-diluted ink on the one hand and patches of ink of different sizes on the other. The variety of grey tones and differing density of the spots produced a highly dynamic formal arrangement. The technique Gerstl employed in the self-portrait shown on page 72 is basically characteristic of drawing. Oval squiggles, which can mainly be seen in the hair, and strokes of the pen in the face remind one of the engraving process. The drawing has a close relationship to sheets by van Gogh, especially his drawings of landscapes.

Four additional drawings that contrast stylistically with the group of divi-
sionistic works were made in the years 1907 and 1908. Fig. 2, which is also in
the Prints and Drawings Collection of the Albertina, shows Gerstl's head,
with an almost ferocious gaze, from the front. The artist captured his image
in rapid, confident strokes of the brush and pen. His note of "29 Sept." on the
side makes it quite clear that this is one of Gerstl's last works. The bitterness
of the self-portrayal should probably be interpreted biographically.

3

Alois Gerstl's biographical notes on Richard Gerstl, which he set down
46 years after his brother's death, are – together with those by Richard's fellow
student Victor Hammer from the year 1963 – an important source of informa-
tion on the life and personality of the artist.

During his lifetime, his painting did not meet with any favour. This did
not disturb my brother because he did not [have] a very high opinion of
the painters who represented art at the time but was completely convinced
of himself and his work. After his death and later, this rejection of his art
was possibly interpreted as the reason for his suicide. This was absolutely
not the motive; it was an unhappy love affair.

He never moved in artists' circles but became friendly with musicians. At a
time when Schönberg was not well known and his music all the more the
object of hostility, my brother was a great admirer of his compositions. In
addition to Arnold Schönberg, to whom he had a close relationship, he
socialised with Alexander Zemlinsky and Schönberg's pupils Alban Berg
[and] von Webern. [He] spent the summers of 1907 and 1908 with Schönberg
and Zemlinsky in Traunkirchen. My brother also had a friendly relation-
ship to the pianist Conrad Ansorge from Berlin. He knew Gustav Mahler,
Peter Altenberg and Paul Stefan personally.

My brother was a great music lover. He sometimes went to the opera three
times a week and never missed an important classical concert. His com-
mand of Spanish and Italian was so good that he was able to study scien-
tific and philosophical works in both languages.

4

Probably on 9 November 1908, shortly after Richard Gerstl's suicide, Mathilde Schonberg wrote a letter to Gerstl's brother Alois:

[…] I would have much preferred to speak to you personally but I felt so unwell and run-down after the tragedy that this was impossible for me. I hope, however, that I will be able to talk to you when we are all somewhat calmer. – I would like to ask you that, if you should find any things in Richard's studio that you feel might belong to me, you simply destroy them. Please do not send anything to me. Any reminder I have of this tragic incident is so terribly painful. – Believe me; Richard took the easiest way out of the two of us. It is so difficult to have to live in such circumstances.

The studio in which Mathilde thought some of her things might be found was the one at Liechtensteinstrasse 20 in the ninth district of Vienna that Richard Gerstl rented in mid-October 1908. This shows that Mathilde continued her affair with Gerstl clandestinely even after the fateful escalation that had taken place only a few months before, and that she visited him in his studio up until his suicide. Alois knew about the developments in the affair and that is the reason that, deeply moved by the death of her lover, she was able to make this request in complete confidence.

SOURCES

—

PHOTO CREDITS

The exhibits were made available or were
supplied by kind permission of the Leopold
Museum, Vienna, or by the museums and
collections named below:
(The figures refer to page numbers)

akg images: 30, 53
Albertina, Vienna: 72, 75 r.
Archiv Otto Breicha, Vienna: 60, 65, 67,
 69 centre l., 69 bottom r., 71 top
© Belvedere, Vienna: 20, 26, 45, 47
© KHM-Museumsverband, Vienna: 16
© Kunsthaus Zug: Frontispiece, 35, 37 top, 49 l.,
 52
Photo © Museum Moderner Kunst Stiftung
 Ludwig, Gift of the Kamm Family, Zug: 50/51
Tiroler Landesmuseen, Innsbruck: 27
© Wien Museum, Vienna: 22, 28

—

NOTES REGARDING THE SOURCES OF
THE TEXTS IN THE ARCHIVE

Gerstl's letter of complaint to the Ministry of
Culture and Education was kindly made
available by the Leopold Museum, Vienna: 75 l.
Excerpt from: Alois Gerstl: "Biographische
Aufzeichnungen über Richard Gerstl" from
1954, pp. 137–140, in: Otto Kallir: "Richard Gerstl
(1883–1908). Beiträge zur Dokumentation seines
Lebens und Werkes", in: *Mitteilungen der
österreichischen Galerie*, Vienna 1974, vol. 18,
no. 62, pp. 125–193: 76
The letter from Mathilde Schönberg to Gerstl's
brother Alois is preserved in the Archiv Otto
Breicha, Vienna: 77

Published by
Hirmer Verlag GmbH
Nymphenburger Strasse 84
80636 Munich
Germany

Front cover: *Semi-Nude Self-Portrait* (detail),
1902/03, see p. 17
Double page 2/3: *Country Garden with Fence*
(detail), 1907, see p. 36 below
Double page 4/5: *The Schönberg Family* (detail),
1907, see pp. 50/51

—
TRANSLATION FROM THE GERMAN
Robert McInnes, Vienna

—
COPY-EDITING/PROOFREADING
Jane Michael, Munich

—
PROJECT MANAGEMENT
Gabriele Ebbecke, Munich

—
DESIGN/TYPESETTING
Marion Blomeyer, Rainald Schwarz, Munich,
Weil

—
PRE-PRESS/REPRO
Reproline mediateam GmbH, Munich

—
PAPER
LuxoArt samt new

—
PRINTING/BINDING
Passavia Druckservice GmbH & Co. KG, Passau

Bibliographic information published by the
Deutsche Nationalbibliothek
The Deutsche Nationalbibliothek lists this
publication in the Deutsche Nationalbibliografie;
detailed bibliographic data are available on the
Internet at http://dnb.dnb.de.

© **2016** Hirmer Verlag GmbH and the authors

ISBN 978-3-7774-2622-8

Printed in Germany